how artists see
FAMILIES

SECOND EDITION

COLLEEN CARROLL

ABBEVILLE KIDS
A DIVISION OF ABBEVILLE PRESS
NEW YORK · LONDON

**Painters understand nature and love her
and teach us to see her.
—Vincent van Gogh**

This book is dedicated to my beloved family: Mitch, Natalie, Juliet, and Isabel.

My deepest thanks to the many people who helped make this book happen,
especially Robert Abrams, David Fabricant, Matt Garczynski, Ada Rodriguez,
Misha Beletsky, Christina Hogrebe, Colleen Mohyde, and as always,
my husband, Mitch Semel.
—Colleen Carroll

Front Cover: Mary Cassatt. *The Child's Bath*, 1893. (see also p. 6)

Editor: Matt Garczynski
Design: Misha Beletsky
Layout: Ada Rodriguez
Production Manager: Louise Kurtz

Second edition
1 3 5 7 9 10 8 6 4 2

Library of Congress Cataloging-in-Publication Data available upon request

For bulk and premium sales and for text adoption procedure, write to Customer Service Manager,
Abbeville Press, 655 Third Avenue, New York, NY 10017, or call 1-800-Artbook.

Visit Abbeville Press online at www.abbeville.com

contents

Claude Drawing, Françoise and Paloma
by Pablo Picasso

The world is made up of many different cultures. Yet all cultures have at least one thing in common—the family. What is a family?

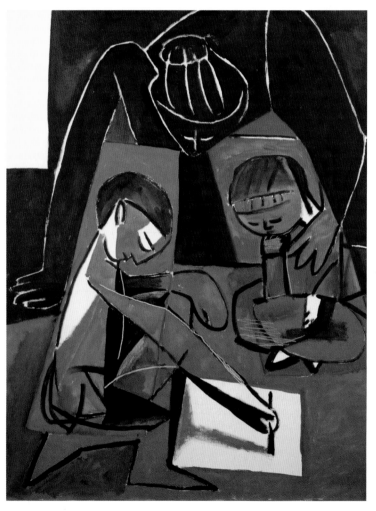

For thousands of years, artists have been trying to answer that question. Just as no two families are alike, no two artists show families in exactly the same way. In this book, you'll discover some examples of how artists see families. Some of the families you meet just might remind you of your own.

In this sweet family scene, a young boy draws a picture while his mother and little sister look on. All eyes are on the boy's hand as it moves around the bright white paper. He has only recently begun his artwork. What do you think he might be drawing? Light from the window falls on the paper. In what other parts of the picture do you see patches of light?

Simple shapes, lines, and bold colors work together to give this picture its energy. Trace all the lines that form the bodies of the children. What shapes do the lines form? The mother is made from thin lines, yet she takes up much of the picture's space. Why do you think the artist made her so large? She

gently places her arm around her daughter. How does this simple gesture convey her love for her child?

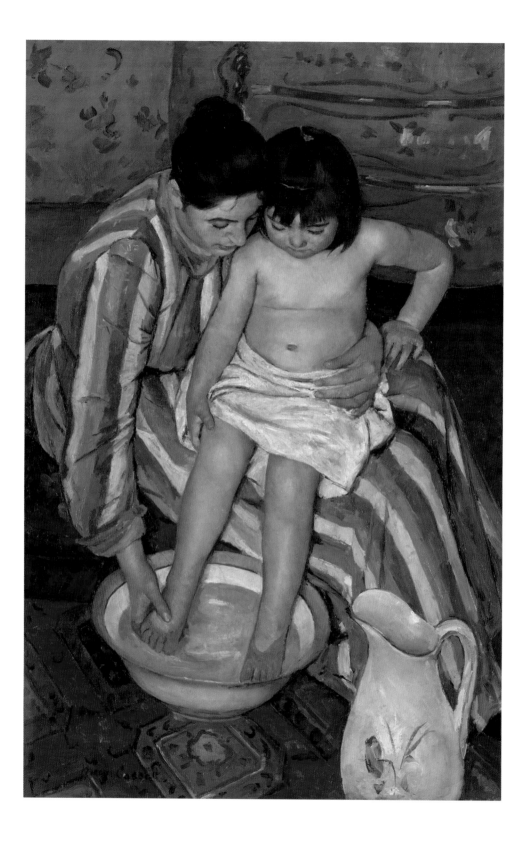

The Child's Bath and The Bath
by Mary Cassatt

The two pictures you see here were made by the same artist. The picture on the left is an oil painting; the one on the right is an

etching, a draw-ing that is *etched* in metal, inked, and printed on paper. In the painting, the mother gently washes her young daughter's feet, while the girl looks on with rapt atten-tion. In the etch-ing, the mother tests the water temperature as her baby tries to squirm away. What do you

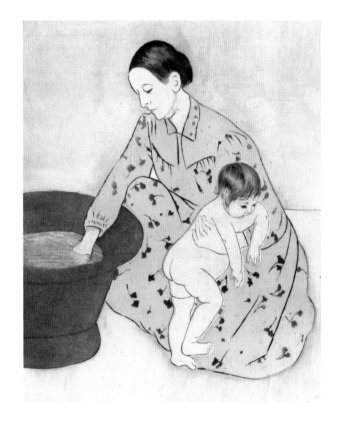

think the baby is looking at? Although the subjects are the same, there are differences between the two works of art. Where do you see the differences?

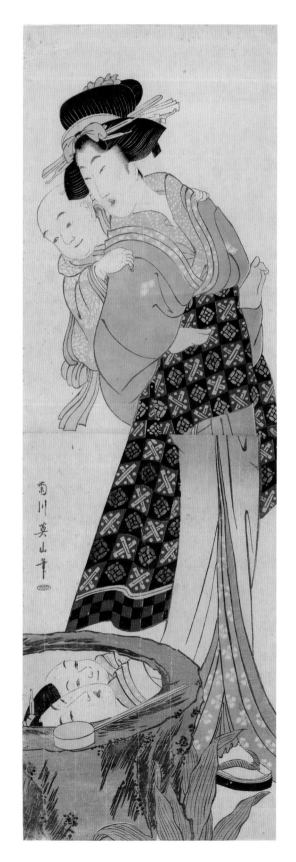

Mother Carrying Her Baby
Son on Her Back
by Kikugawa Eizan

In this beautiful picture, a mother and her baby share a moment of
pleasant surprise as they gaze into a pool of water. What do they
see? If you noticed their reflections, you have a very keen eye. (If
you don't see them, try turning the picture on its side.) The baby
stares at his reflection with amusement. What do you suppose he
is thinking?

The artist used
many lines to cre-
ate this picture.
Trace your finger
over all the lines
you see. Many
of the lines are
curved, such as
the ones on the
mother's flow-
ing kimono. These lines make her look slender and graceful. What
words would you use to describe this young mother? As she arches
her back, her whole body forms another curve. Move your finger
along the right side of her body to follow its serpentine path.

9

Clan Mother
by Richard (Rick) W. Hill Sr.

To the people of the Six Nations, a clan mother is a greatly respected person. In this watercolor painting, the clan mother cups her left hand on the baby's head and looks into the distance. Perhaps she is considering a name for the child. The artist placed the woman and baby in the center of the picture, and together they form a triangle. With your finger, trace the three lines of the triangle. By composing the picture in this way, the artist helps your eye focus on the most important part of the painting. In what other ways does the artist draw your attention to the clan mother?

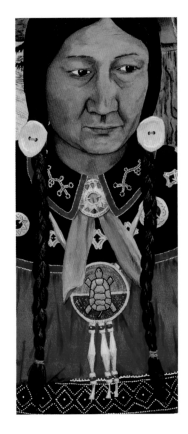

In this picture, nearly everything you see is a *symbol*. The white pine, with its roots spreading in four directions across the forest floor, is a symbol of peace; the spring strawberries are symbols of new life. Each animal represents a group of families called a *clan*. How many animals can you spot? The clan mother is part of the turtle clan. How do you know?

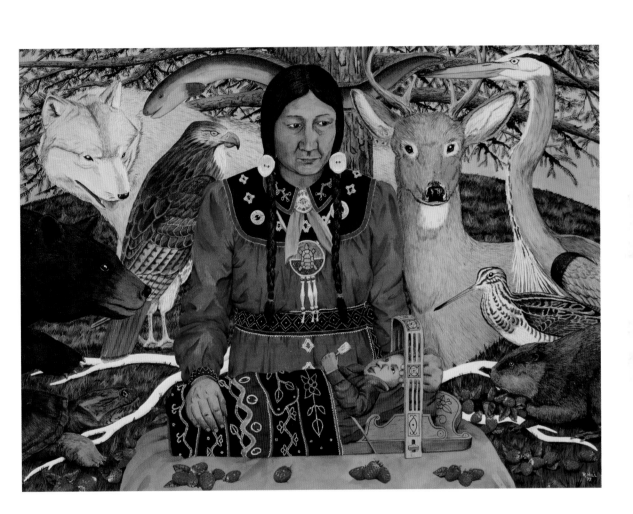

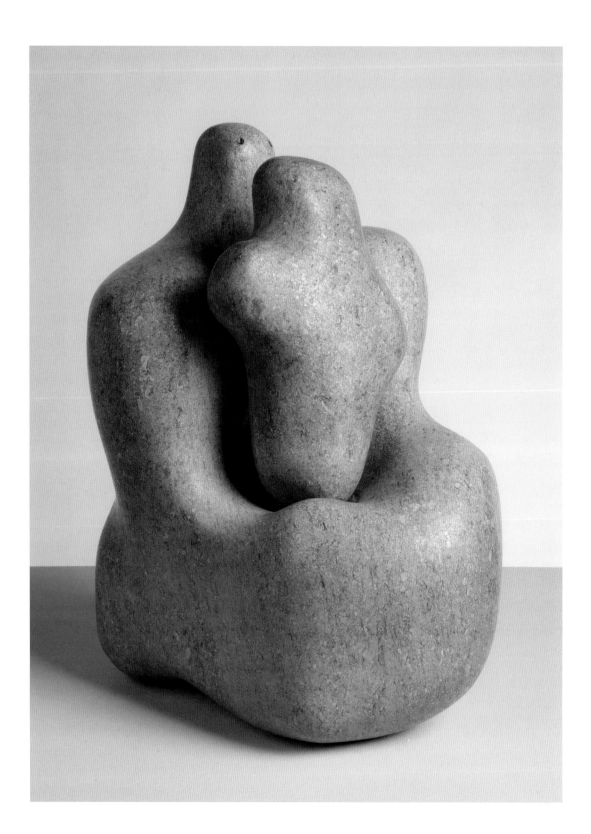

Mother and Child

by Barbara Hepworth

This, too, is an artwork of a mother and child, though it is quite different from the pictures you've already seen. In this sculpture carved from pink stone, a seated mother holds her chubby baby in her lap. Their faces are so close together, they almost touch. Trace your fingers around the curves of the mother's body. Now trace your finger around the baby. How do these lines help you imagine the closeness they feel for one another?

The artist polished the stone until it was as smooth as a newborn baby's skin. In what other ways does the artist help you feel the warmth between this mother and her baby? Although this sculpture is small, the love and connection these two people convey is gigantic. What words would you use to describe this mother and her child?

First Steps
by Jean-François Millet

and

First Steps, after Millet
by Vincent van Gogh

These pictures capture the thrilling moment when a small child walks for the first time. The smaller picture, which is a drawing, was made first. The larger picture, an oil painting, was made a few years later by a different artist. Look carefully at both pictures. At first they seem to be nearly exactly alike. In what ways did the younger artist make his version of this subject his own?

In both pictures, the mother supports the child, whose outstretched arms mirror the father's. With your finger, draw a line between father and baby. This straight line helps you focus on the thrilling event about to happen. Soon, the mother will let go and allow the baby to take those first wobbly steps. Do you think the child will reach the father's arms without falling? What do you think each parent is feeling and saying at this moment?

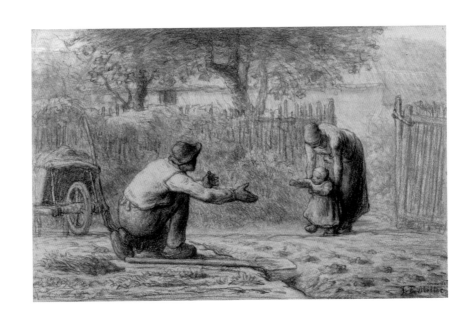

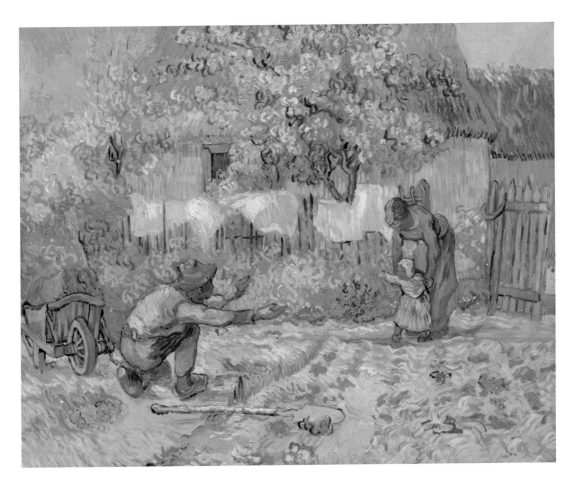

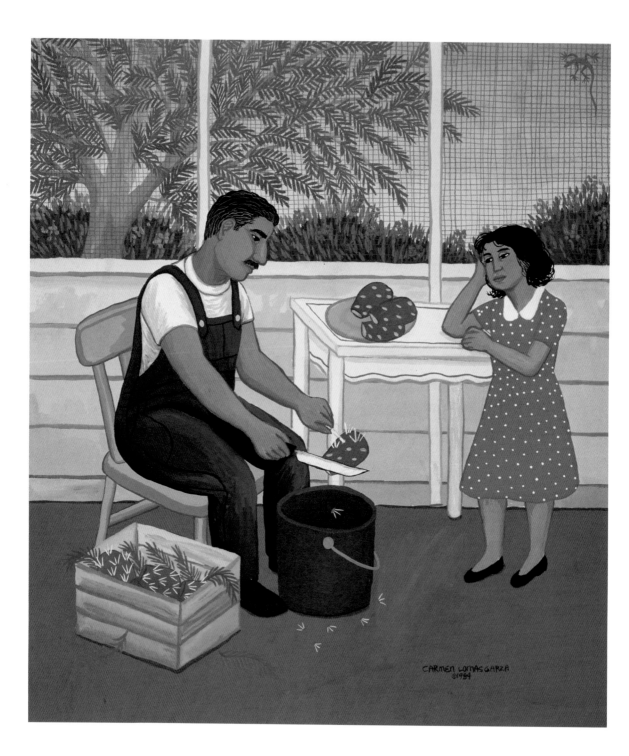

CARMEN LOMAS GARZA
©1989

Cleaning Nopalitos
by Carmen Lomas Garza

Some of the most special family memories are made at home doing simple tasks with loved ones. In this picture, based on a memory from the artist's childhood, her sister watches their grandfather shave the thorns from a nopalito, or prickly pear. Sitting on the family's screened porch, the grandfather expertly slices the sharp prickers into a bucket. Three cleaned nopalitos rest on a plate. On the floor next to him sits a crateful of the cactus pads waiting to be cleaned. How much longer do you think this job will take?

The little girl rests her head in her hand as she leans on the yellow table. She pays close attention as her grandfather works. Do you think the little girl wants to help? Perhaps the fleshy fruit will be turned into a delicious dish for a family celebration. Look at her expression. If she could talk, what do you think she would say to her grandfather?

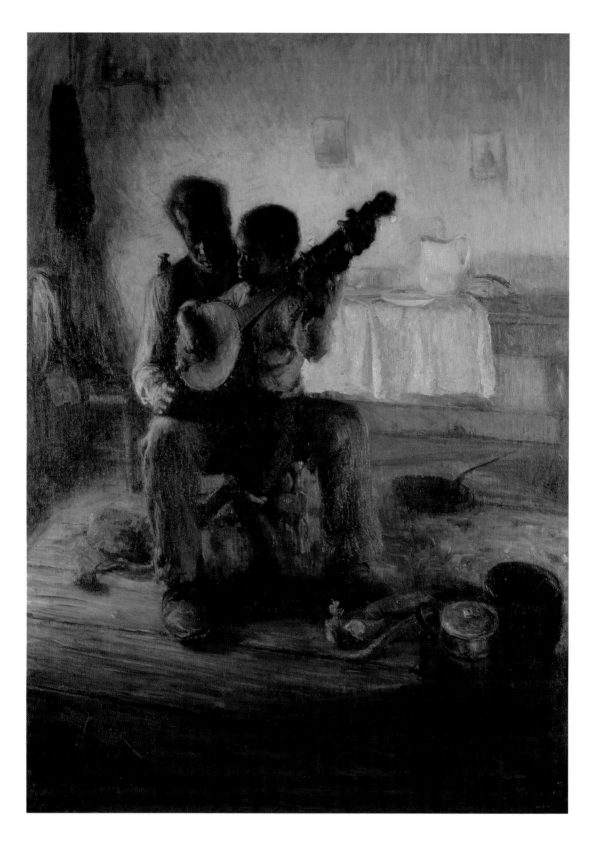

The Banjo Lesson
by Henry Ossawa Tanner

Like memories, traditions are important parts of a family's history. In this picture, a father (or perhaps a grandfather) teaches his young son how to play the banjo. Holding the neck of the instrument at the proper angle, he watches patiently as the boy tries to finger the right chords and pluck the metal strings. How do you think the father feels to be sharing his knowledge?

In this simple, dimly lit room, you cannot see the pair very clearly. The back of the room is lit by a pinkish yellow glow, perhaps from a candle or a kerosene lamp on the wooden table. Although father and son are mostly in shadow, a warm orange light falls on the boy, highlighting his focused expression and the fingers of his left hand. How does this warm light help express the feelings they have for each other?

The Dreamers

by Mark Shasha

In this picture, a father and son have come upon a surprising view. The boy holds a small toy boat in his right hand as he watches the elegant sailboat cut through the water. What do you think his expression looks like at this moment? The artist called this painting *The Dreamers*. As they gaze out at the vessel, what do you think they are dreaming about?

It would be hard to imagine a more beautiful day to go hiking or sailing. The artist floods the picture with light and color to help you imagine the feeling of this moment. The pink sails cast their light on the water, changing the teal blue sea to light green. How do the colors the artist chose give you a feeling for what the weather is like on this lovely day?

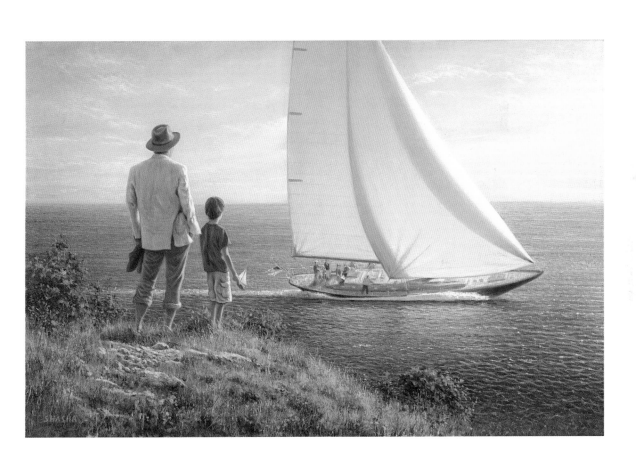

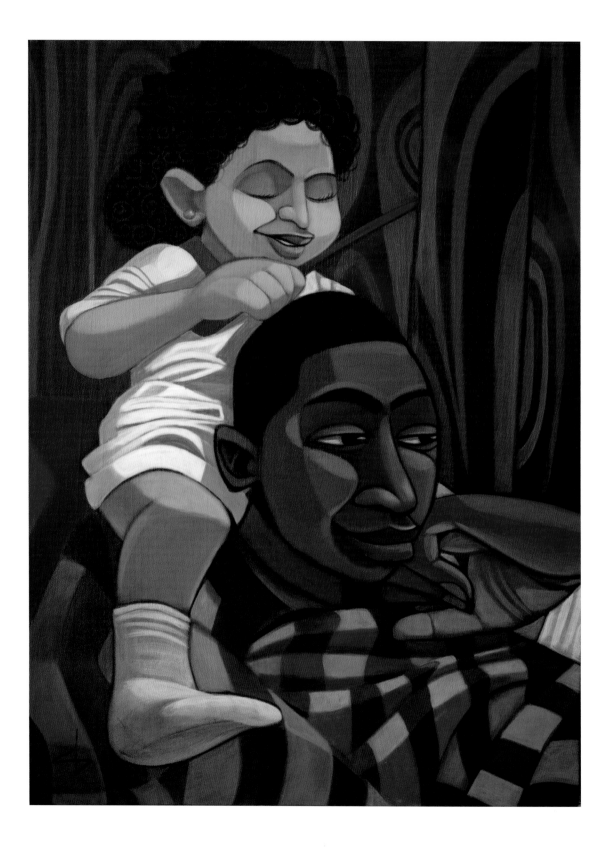

Missed a Spot
by Cbabi Bayoc

What child doesn't love going on a grown-up outing with Dad? In this picture, a young girl and her dad are at the barbershop. Sitting atop his shoulders, she carefully combs his freshly cropped hair. As she plays barber, her father rests his head against his hand, mouth upturned in a smile. Who do you think is having more fun, father or daughter?

The artist painted this picture using lines and colors to capture a sweet family moment. Dad is covered in a bright blue cape with wide straight lines, and he sits in front of a multicolored paneled wall made of curving lines. What do these lines look like to you?

23

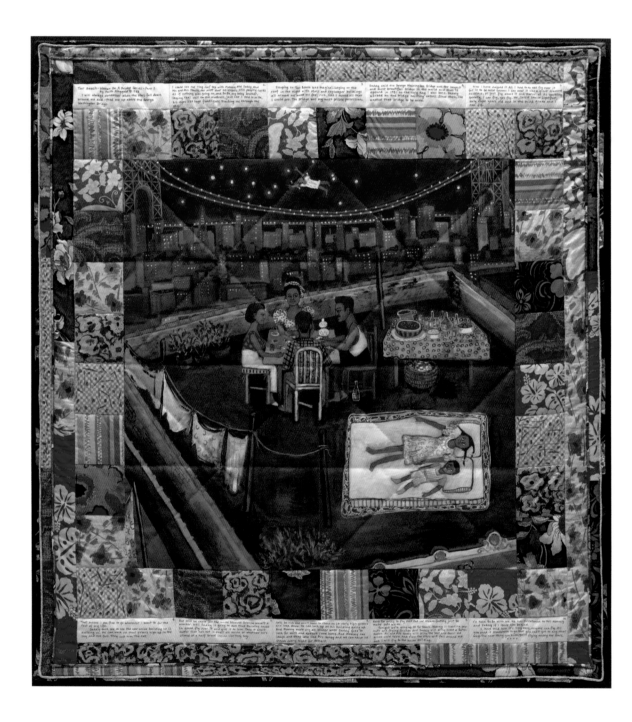

Tar Beach
by Faith Ringgold

Here is another work of art based on a memory from the artist's childhood. There are many details in the scene, such as the table laid out with a delicious meal and New York City's twinkling skyline. What other details do you see? The artist painted herself lying on a mattress next to her brother. She also appears in another part of the picture. What is she doing?

 Although this artwork is a painting, it's also a quilt. The main part of the picture is painted on fabric. Surrounding the scene are many pieces of colorful fabric stitched together to form the border. If you look closely at the white bands at the top and bottom, the artist shares her memories of feeling completely free as she dreams of flying over the George Washington Bridge. How do you think you would feel if you could fly through the night sky?

Sister
by Hung Liu

In this picture, the artist combined a simple photograph of two sisters with many surprising elements, such as birds, insects, and splotches of paint. What other details do you see? The artist used the color red throughout the picture: the red bird staring at a red beetle, and the red ribbons in big sister's hair. Why do you think the artist used this color so often?

The older sister carries the toddler on her back, but the artist doesn't show us what they are doing or where they are going. As if they have stopped to say hello, the faces of the children invite you to greet them in return.

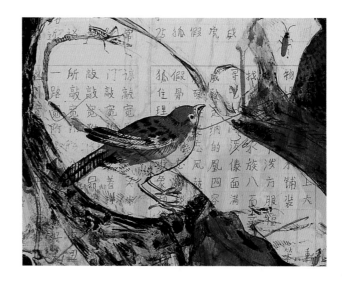

The younger sister, as many toddlers do, places a finger in her mouth. Her sweet smile and shining eyes convey happiness. Look at the older sister. Does she look as happy? How would you describe the expression on her face?

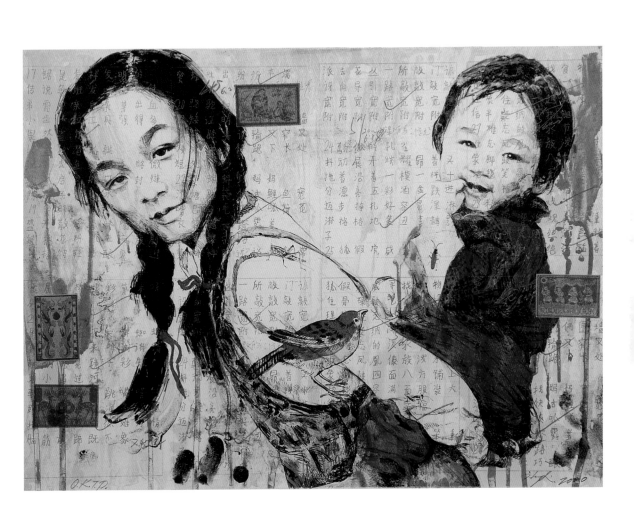

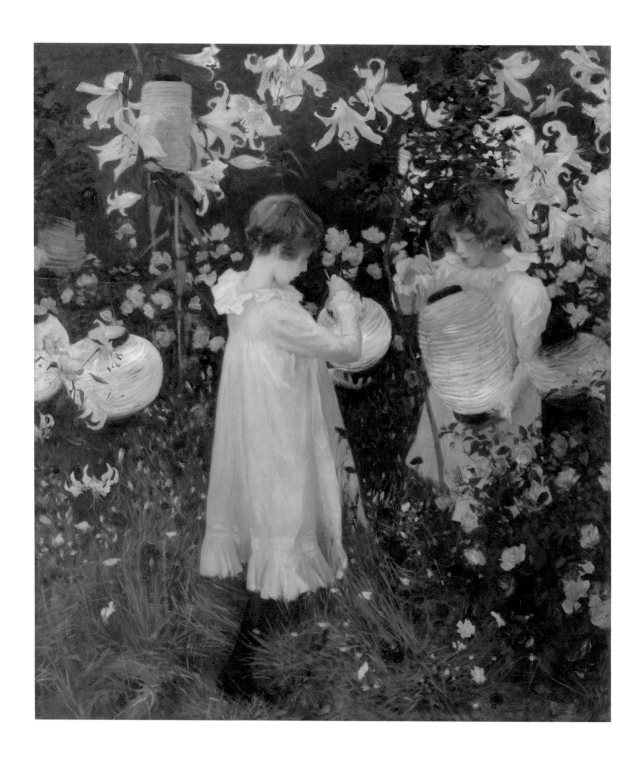

Carnation, Lily, Lily, Rose

by John Singer Sargent

This beautiful picture invites you into a lush garden at dusk, just as two sisters light a pair of paper lanterns that glow like magical beehives. How many lanterns can you find? The light they shed makes the flowers stand out vividly against the dark green foliage and highlights the delicate arch of white lilies that frame the girls going about their

work. Trace your finger around the arch of flowers.

The lanterns cast a soft pink light on the girls' faces and on the petal-like ruffles of their matching dresses. Standing amid the pink and white blossoms of this twilight garden, the sisters blend in with their surroundings as they carefully light the lamps. Try to imagine the fragrance of this summer evening. What does it smell like to you?

Two Sisters

by Kehinde Wiley

Here is another pair of sisters in white gowns, surrounded by flowers. Like the young sisters in the evening garden, these sisters seem to glow with light. Where does the light seem to be coming from? Dressed like goddesses, these sisters stare proudly and confidently back at you. What words would you use to describe these women?

Another thing this picture has in common with the one you just saw is that the sisters stand among flowers. At first glance, the flowers appear to be part of a screen or a piece of wallpaper. But look more carefully, and you'll see

that some of the plants have broken free from the background and float in front of the sisters. How is this garden similar to the one in *Carnation, Lily, Lily, Rose*? How is it different?

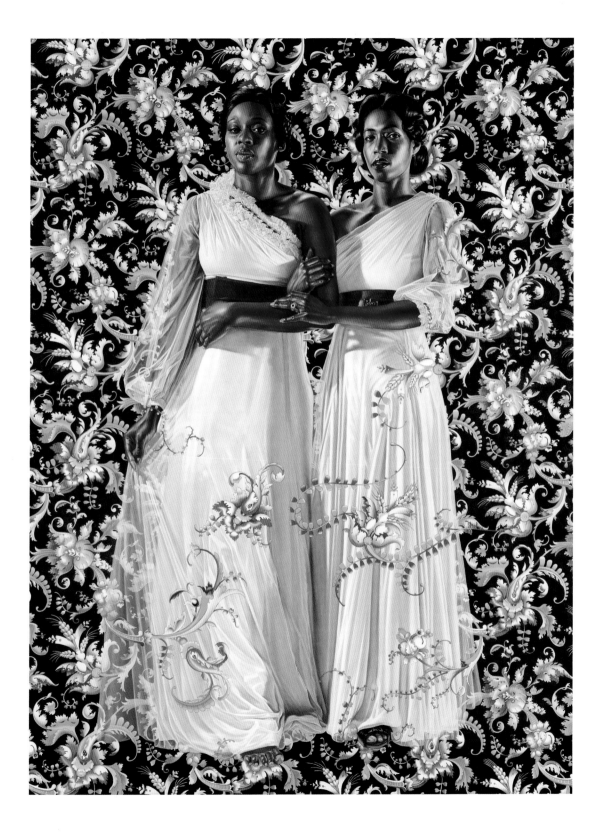

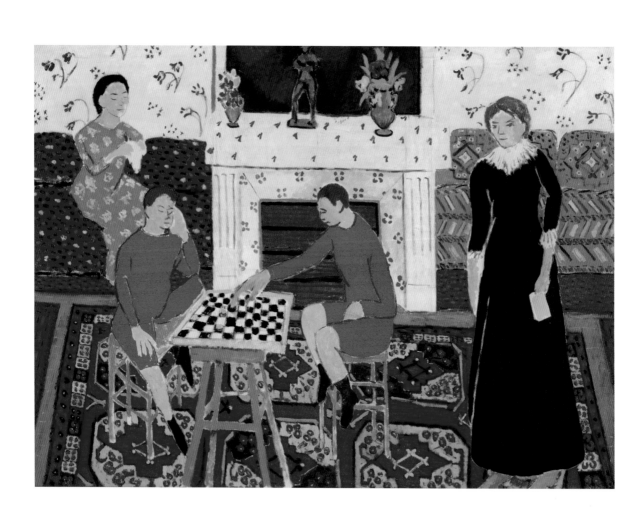

The Painter's Family
by Henri Matisse

It's easy to tell who the brothers are in this picture. Dressed in bright red clothing, the boys are engrossed in playing a board game. The detail on this page shows the boy on the left, who rests his head against his hand as he observes his brother making a move. What could he be thinking? The game seems to be coming to an end. How can you tell? Who do you think is winning?

You've probably noticed the colorful patterns that decorate the room. How many different patterns can you find? The artist dressed the boys in solid red clothing so they would show up clearly among all the patterns. Likewise, a woman on the right side wears a black dress, which helps her to stand out against the background patterns. Who do you think she is?

The Louvin Brothers
by Wayne White

Meet the Louvin Brothers! That's Ira on the left, plucking his man-
dolin, and Charlie on the right, strumming the guitar. If you were
in the museum where this whimsical sculpture is on display, you'd

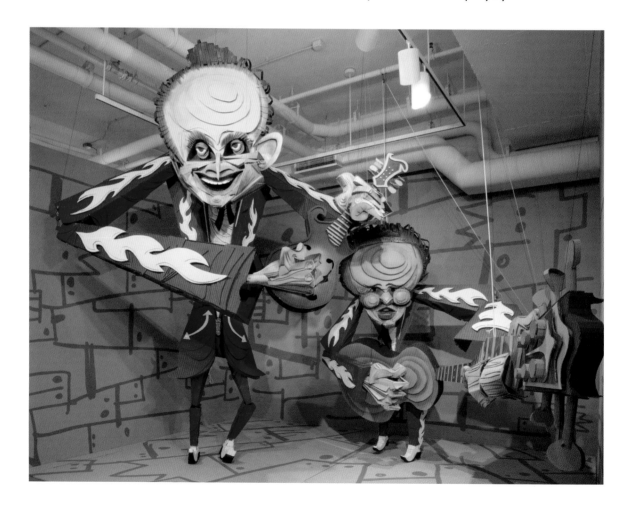

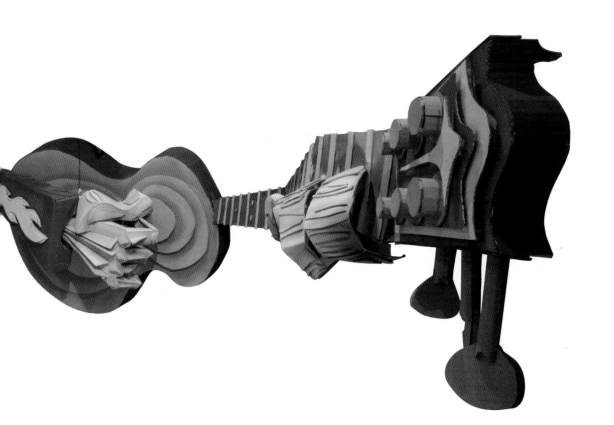

have to look up. Ira is 15 feet tall! These *kinetic* sculptures are also puppets, attached to ropes that can be pulled to make their bodies move. Imagine pulling the rope attached to Charlie's guitar. How would the moving parts help you imagine the brothers performing their songs? What does the music sound like to you?

Made from cardboard, wood, and paint, the puppets project a sense of fun, rhythm, and movement. Lines jump and pulsate to give the figures their own energy, like drawings that have come to life. Trace your finger over the lines of Charlie's guitar. Where else do you see similar bold lines?

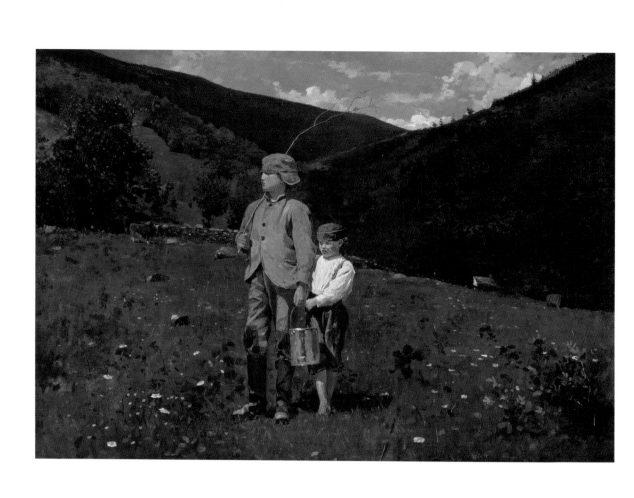

Crossing the Pasture
by Winslow Homer

What would you do if you encountered a bull in a wide, open field? That's exactly what is happening to the two brothers in this picture. Examine the background and you'll find the bull staring in their direction. They stand perfectly still, perhaps hoping the bull will lose interest and go on its way. The older brother seems calm and ready to protect his sibling, who stands behind him for protection. Look at the younger brother's expression. What do you think he is feeling?

The artist placed the brothers front and center in the picture. Behind them, a field rolls into the distant hills. A small white house sits far in the background. How does the open space add suspense to the scene? Do you think they'll make it home safely?

The Soyer Brothers

by Alice Neel

In this painting, twin brothers and artists Raphael and Moses Soyer sit for their portrait. At the time, they were seventy-four years old and looked every bit their age. Look closely at their hands. How do you know these are not the hands of young men? In what other ways does the artist show the brothers' age?

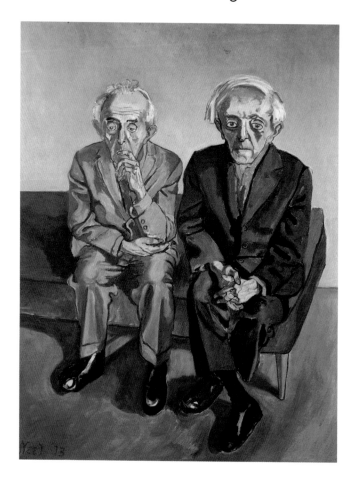

Crockett Brothers

by Jordan Casteel

Here is another pair of brothers, portrayed similarly to the one you just saw. Sitting in matching chairs in a cozy room, the siblings appear relaxed and happy, gently leaning toward one another. The brother on the left clutches a saxophone. Why do you think he chose to hold his musical instrument? If you could choose a favorite object to represent you, what would it be?

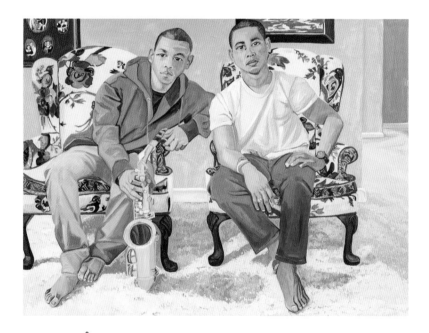

As you have seen, artists have different ways of expressing what it means to be a family. And just as every artist's style is unique, every family is special in its own way. With that in mind, make an artwork that celebrates your own family—in your one-and-only style.

Note to Parents and Teachers

Over the years I've shown children many examples of great art, both as a teacher and as a visiting author to schools across the United States. I am always amazed at how enthusiastically children respond to art, and how their imaginations are fired by the colors, lines, and shapes, the subject matter, and the moods and feelings of the artworks. When I ask them challenging questions about art, they engage with it even more actively, and their thoughts lead them in all sorts of interesting directions. In today's world, providing children with healthy ways to build visual literacy skills is as important as ever. Looking closely at art and talking about it is one excellent way of doing just that.

How Artists See teaches children about the world by looking at art, and about art by looking at the world. Each volume is devoted to a universal subject in art, so that children can see how different artists have approached the same theme and begin to understand the importance of individual style. The questions in this book are open-ended, with no right or wrong answers—they are meant to encourage children to look critically and ask thought-provoking questions of their own.

How Artists See is not an art history primer, but for children who want to learn more about the artists whose works appear in the book, I've provided short biographies at the end, along with books and websites with more in-depth biographical and historical information.

After reading *How Artists See Families*, children can do a variety of related activities, such as drawing or painting a family portrait, constructing a family tree, or planning and cooking a special family meal. Pull out the family photo albums and let children select pictures of ancestors to make a family history collage, or lead children on a scavenger hunt through a museum or library to find more works of art that depict families around the world.

I hope that you and your children or students will enjoy reading and rereading this book and, by looking at the many styles of art, discover how artists share with us their unique ways of seeing the world.

—Colleen Carroll

Pablo Picasso
(1881–1973)

Picasso (pronounced *pea-KAH-so*) was born in Spain, but for most of his life lived and worked in France. Many people consider him the most important artist of the twentieth century. Picasso began to draw as a young boy, amazing teachers and family members with his talents. After attending art school he moved to France, where he would help change the course of art. Throughout his long life he explored many different styles of art, but he is perhaps best known for Cubism, in which the subject is made with many different shapes and seen from more than one angle. Cubism shook the art world— it was completely new! Picasso lived to be an old man, and his paintings, drawings, sculptures, and ceramics can be seen in museums all over the world.

Picasso, Pablo. *Birds & Other Animals with Pablo Picasso*. New York, NY: Phaidon Press, 2017.

"Who is Pablo Picasso?" Tate Kids. https://www.tate.org.uk/kids/explore/ who-is/who-pablo-picasso

Mary Cassatt
(1844–1926)

Born into a wealthy family, the American Painter Mary Cassatt (pronounced *kuh-SAHT*) traveled throughout Europe when she was young. On these trips she was exposed to works of the European masters, whose works inspired her to become a professional artist. She studied art at the Pennsylvania Academy of Fine Arts in Philadelphia and later in Italy and Paris, where she moved in 1874. There, she met the Impressionist artist Edgar Degas. They quickly became friends, and soon Cassatt began painting in a style similar to Degas' and the other Impressionists', and she even exhibited her own work with Degas' on many occasions. She is best known for her portraits of mothers with their children and of women doing everyday activities, such as reading or writing a letter. Besides being an accomplished painter, she was also a printmaker, and many of her prints were influenced by the Japanese woodcuts so popular in late-nineteenth-century Paris (see *Mother Carrying Her Baby Son on Her Back*).

"Hey Kids, Meet Mary Cassatt." MakingArtFun. http://makingartfun.com/ htm/f-maf-art-library/mary-cassatt- biography.htm

Kikugawa Eizan
(1787–1867)

The son of a craftsman, Kikugawa Eizan (pronounced *ay-ZAN*) was born in Edo, the present-day city of Tokyo, Japan. His father made artificial flowers for a living and was the first to teach his son how to paint. Eizan studied and mastered the style of Japanese art known as *ukiyo-e*. *Ukiyo-e* means "the floating world," and

its subject matter depicts the pleasures of daily life. As a young artist, Eizan became popular for his prints of beautiful, slender women in standing poses, such as the one seen in this book. His art and that of other ukiyo-e artists influenced the American painter and printmaker Mary Cassatt and the French Impressionists (see *The Bath*).

Ministry of Foreign Affairs of Japan. "Virtual Culture: Ukiyo-e." Kids Web Japan. https://web-japan.org/kidsweb/virtual/ukiyoe/index.html

Richard (Rick) W. Hill, Sr. (born 1950)

Richard "Rick" Hill is a Haudenosaunee (pronounced *HO-dee-no-SOHN-ni*) artist, writer, educator, curator, museum consultant, and advocate on issues that affect the lives of Native Americans. A member of the Beaver Clan of the Tuscarora tribe, he is skilled in a variety of art forms, including painting, photography, carving, beading, and basket weaving. Hill studied art at the Art Institute of Chicago and the State University of New York, Buffalo, where he received his master's of art degree. His work with various museums, such as the American Indian Art Museum and the National Museum of the American Indian, seeks to address the way Native American history is communicated to the public. His artworks can be found in many permanent collections in the United States and Canada. Rick Hill lives in Ontario, Canada.

Barbara Hepworth (1903–1975)

This British sculptor became a highly regarded and respected artist in a field that at the time had few women. At the age of 17, Hepworth earned a scholarship to art school. She continued her studies in England and Italy, eventually setting up a studio in a home where she would live for the rest of her life. Her early sculptures were realistic, but as she grew older they became more and more abstract. She worked in many materials, such as wood, stone, steel, and bronze. Some of her works are small, such as the one in this book, and some are nearly two stories tall, such as the one that sits in front of the United Nations Secretariat Building in New York City. Hepworth believed that the viewer should interact directly with a piece of sculpture, and once said, "You can't look at a sculpture if you are going to stand still as a ram rod and stare at it . . . you must walk around it, bend toward it, touch it, and walk away from it."

Carlin, Laura. *Meet Barbara Hepworth*. London: Tate Publishing, 2015.

Tate. "Who is Barbara Hepworth?" Tate. org.uk. https://www.tate.org.uk/art/artists/dame-barbara-hepworth-1274/who-is-barbara-hepworth

Vincent van Gogh (1853–1890)

Even though this Dutch artist produced work for only ten years, he left behind hundreds of paintings and drawings that are among the world's most famous and beloved artworks. Vincent van Gogh

(pronounced *van-GO*) used bright colors and thick brushstrokes in his paintings of people, still lifes, and landscapes. He liked to paint outdoors in full sunlight, and often painted two pictures a day. His brother Theo worked for an art dealer and sent Vincent paints and canvas so that he could spend most of his time painting. Even though most people did not understand or appreciate Van Gogh's art during his lifetime, today he is thought to be one of the greatest artists who ever lived.

Geis, Patricia. *Vincent Van Gogh: Meet the Artist!* New York: Princeton Architectural Press, 2015.

"Vincent van Gogh's Life and Work." Van Gogh Museum. https://www.vangoghmuseum.nl/en

Jean-François Millet (1814–1875)

The French painter Jean Millet (pronounced *MEE-yeh*) was the eldest child in a family of farmers. He worked the fields as a child, and at age 19 he left home to work for a painter in a neighboring village. In his early twenties he enrolled at the Ecole des Beaux-Arts in Paris. Early struggles to earn a living as an artist led him to leave Paris, but he eventually returned and began to be recognized for his art. Millet is most known for his paintings of humble farm workers. The artist was part of a group of French painters known as the Barbizon School, who painted outdoor landscapes and especially forests. Millet's work influenced and the Dutch artist Vincent van Gogh, as seen in the two pictures in this book.

National Gallery of Art. "Jean-François Millet." NGA.gov. https://www.nga.gov/collection/artist-info.1720.html

Carmen Lomas Garza (born 1948)

"I wanted to depict in fine art form all the things of our culture that are important or beautiful or moving." The Mexican-American artist Carmen Lomas Garza does indeed capture and celebrate her Latina heritage in paintings that depict memories of her childhood in a small town near the Mexican border. Born in Kingsville, Texas, Lomas Garza knew as a teenager that she wanted to become an artist. After getting a master's degree in art and education, she worked for a short time in an art gallery before becoming a full-time artist. She is also an accomplished printmaker and the author of many books.

Lomas Garza, Carmen. *Family Pictures.* 15th Anniversary Edition. New York: Children's Books Press, 2005.

Henry Ossawa Tanner (1859–1937)

This American painter was born in Pittsburgh, Pennsylvania, to parents who valued education and culture. His mother, a former slave, was a schoolteacher; his father was a minister and crusader for social justice. One of Tanner's art teachers was the American realist painter Thomas Eakins. He painted for a period of time in the United States, and at age thirty-two moved to Europe to escape the racism that he faced in his home country. As he once said, he could not

"fight prejudice and paint at the same time." Best known for landscapes and scenes from the Bible, Tanner was the most successful African-American artist of his generation. In 1996 his painting *Sand and Dunes at Sunset, Atlantic City* became the first artwork by an African-American artist to be represented in the White House Collection.

"Henry Ossawa Tanner." Smithsonian American Art Museum. https://americanart.si.edu/artist/henry-ossawa-tanner-4742

Ringgold, Faith. *Henry Ossawa Tanner: His Boyhood Dream Comes True*. Piermont, NH: Bunker Hill Publishing, 2011.

Mark Shasha
(born 1961)

This award-winning artist has had a long and varied career as an illustrator, author, and painter. After graduating from the prestigious Rhode Island School of Design in 1983, Shasha moved to Boston to start a career as an illustrator, producing illustrations for newspapers and magazines. As a painter, Shasha works both in a studio and *en plein air*, a French term that means "outdoors." His favorite subjects are seascapes, landscapes, and people, in works that capture the magnificent scenery of the New England coastline. Shasha is also the author of two children's books, *Night of the Moonjellies* (1992) and *The Hall of Beasts* (1994). Shasha lives in New England, where he paints, acts in community theater, and teaches painting workshops.

"About" MarkShasha.com. https://markshasha.com/about

Shasha, Mark. *Night of the Moonjellies*. 25th Anniversary Edition. Cynthiana, KY: Purple House Press, 2017.

Cbabi Bayoc
(born 1972)

As a child, this New Jersey-born painter and illustrator wanted to be a truck driver. He ultimately decided to attend art school because he liked to draw cartoons, and graduated with a bachelor's degree in painting and drawing. After college he landed a job as a caricature artist at an amusement park, and also worked as a magazine and commercial illustrator before devoting himself full-time to painting. Born Clifford Miskell, the artist changed his name to Chabi Bayoc (pronounced *kuh-BOB-bi BAY-ock*), which stands for: **C**reative **B**lack **A**rtist **B**attling **I**gnorance and **B**lessed **A**frican **Y**outh of **C**reativity, a name that reminds him of his purpose in life. His favorite subjects are African-American musicians, family life, and birds. In 2014 his project "365 Days with Dad" went viral on social media. One of those paintings, *Missed a Spot*, is featured in this book.

"Cbabi Bayoc." cbabibayoc.com. http://cbabibayoc.com/index.php/about/cbabi

Trice, Mon, and Cbabi Bayoc. *Cannon's Crash Course*. St. Louis, MO: Pageway Publishing, 2016.

Faith Ringgold
(born 1934)

American artist and writer Faith Ringgold (pronounced *RIN-gold*) was born in Harlem, an area of New York City. Her mother, who was a fashion designer, seamstress, and quilt maker, taught her young daughter how to sew and encouraged her artistic interests. Ringgold attended college and eventually earned a teaching certificate and a master's degree in fine arts. While in college she began to explore African-American themes and subjects, and would mix her paints to create realistic skin tones. For many years she taught art in the New York City public school system, and at the same time she worked to develop her own individual style. Best known for her story quilts, Ringgold combines painting, fabric, and writing to create art that is uniquely her own.

Ringgold, Faith. *Harlem Renaissance Party*. New York, NY: HarperCollins, 2015.

Hung Liu
(born 1948)

When the Chinese-born artist Hung Liu (pronounced *LOO*) was six years old, she was with her grandfather, drawing trees in her sketchbook. She struggled with getting the trees to look the way she wanted them to, but her grandfather (who was a teacher), gave her a score of 100 percent. His approval of her work made her realize that she was skilled enough to be an artist. Liu was trained to be a painter while she lived in China, then in 1984 moved to the United States to study art.

In addition to painting, Liu is an accomplished printmaker and video artist. She has also taught art at the college level for over two decades, and has twice received the National Endowment for the Arts Visual Arts Scholarship. Liu is most known for adapting old Chinese photographs, layering the original images with paint and other mixed media.

"Hung Liu: A Question of Hu." HungLiu. com. http://www.hungliu.com/ a-question-of-hu.html

John Singer Sargent
(1856–1925)

The American portrait painter and watercolorist John Singer Sargent was born in Italy to American parents, and traveled with them throughout Europe during his childhood. Sargent eventually moved to London, where he became a successful portrait painter of wealthy and important people. The demand for his portraits, both in England and America, made him a celebrity. He applied paint in strong, free (loose) brush strokes and often spent months working on a single portrait to get the details just right. Toward the end of his life he grew tired of painting portraits and began to paint watercolors of outdoor scenes.

Weinberg, H. Barbara. "John Singer Sargent (1856–1925)." MetMuseum.org. https://www.metmuseum.org/toah/hd/ sarg/hd_sarg.htm

Kehinde Wiley
(born 1977)

Growing up in South Central Los Angeles in the 1980s, Kehinde Wiley's mother would take him to art museums on the weekends. When he was eleven years old, he attended art classes, and spent a period of time in Russia studying art. After high school, Wiley got his undergraduate degree from the San Francisco Art Institute, and a master's degree from Yale University. Interested in classic paintings by European masters such as Titian and Rubens, Wiley began to create larger-than-life sized portraits of African-American men set in poses inspired by many famous paintings. President Barack Obama chose Wiley to paint his official portrait, which was unveiled in 2018 and hangs in the National Portrait Gallery in Washington, D.C.

Ingram, Cindy. "Portraits for a New Century: Kehinde Wiley Art Lesson." Art Class Curator. https://artclasscurator.com/kehinde-wiley-art-lesson/

Henri Matisse
(1869–1954)

During his long lifetime, Henri Matisse (pronounced *mah-TIECE*) worked in many different styles. When he was twenty years old, he was studying to be a lawyer. To pass the time while he was recovering from an illness, he began to draw. Early in his career he was the leader of a group of painters called the Fauves, which in French means "wild beasts." The Fauves believed that color was the most important element in painting and they used it in bold ways. In one of Matisse's early portraits, he painted his wife's face bright green! His favorite subjects included dancers, still life, and interiors of colorful rooms. Late in his life, when he could no longer paint, Matisse made collages out of brightly-colored paper, which he called "cut-outs." Along with Pablo Picasso, Matisse is known as "the father of modern art," because his ideas took art in new directions.

"Art History and Artists: Henri Matisse." Ducksters. https://www.ducksters.com/biography/artists/henri_matisse.php

Parker, Marjorie Blain. *Colorful Dreamer: The Story of Artist Henri Matisse.* Illustrated by Holly Berry. New York, NY: Dial Books For Young Readers, 2012.

Wayne White
(born 1957)

This versatile American artist once said, "My mission is to bring humor into fine art. Not art world funny but real world funny." Wayne White was born and raised in Chattanooga, Tennessee. After college, he moved to New York City and worked as a newspaper and magazine illustrator. In 1986, White began designer sets and puppets for the popular children's television show, *Pee-wee's Playhouse.* He continued to work on other television shows and music videos before deciding to work full-time on his art. White is most known for his "word paintings," in which he paints words and phrases on cast-off, thrift shop landscape paintings, and his sculptural puppets and environments.

"Biography." Wayne White Art. http://waynewhiteart.com/index.php?/bio/

Winslow Homer
(1836–1910)

American artist Winslow Homer was born in New England but moved to New York City as a young man to become an illustrator. When the Civil War broke out, Homer was hired by a popular magazine to paint pictures of the front. After the war, he continued making illustrations but spent more and more time painting scenes from everyday life in the realistic style he is known for. In 1881 he traveled to England, where he lived in a fishing village, an experience that took his art in a new direction. When he returned to America, he began to paint—in both watercolors and oils—rugged pictures of the sea. He liked to use watercolor paints to sketch scenes from nature, especially the seaside, and he used some of these watercolor studies as ideas for his oil paintings.

"Winslow Homer." WikiArt. https://www.wikiart.org/en/winslow-homer

Alice Neel
(1900–1984)

To Alice Neel, art and portraiture was about telling the truth. Born in Pennsylvania, she attended and graduated from the Philadelphia School of Design (today Moore College of Art and Design). After school she moved to New York City. Calling herself "a collector" of souls, Neel presents her subjects with honesty and compassion. Her subjects look directly back at the viewer. Neel's goal was not to make the sitter look pretty, but "real." Whether painting friends, family members, fellow artists, neighbors, or poets, each subject was treated with the same unflinching honesty. In 1974, the Whitney Museum of Art had a retrospective exhibition of Neel's work. This "collector of souls" is considered one of the most important American painters of the twentieth century.

Jordan Casteel
(born 1989)

In a 2018 magazine interview, the American painter Jordan Casteel said, "What is fun about painting is that I can be a magician." Born and raised in Denver, Colorado, Casteel studied art in college and continued her education at the Yale School of Art, graduating with a master's of fine arts degree in 2014. After graduate school, she began teaching painting at Rutgers University in New Jersey, and has had two solo exhibits. Casteel's process begins with a series of photographs that she takes of her subjects, from which she selects particular elements to include in her compositions. Her portraits of black and brown men—some of whom she knows well (such as her twin brother), and some of whom she approaches to be models—show great care for their subjects, such as *Crockett Brothers*.

Major, David W. "Visible Men." *Rutgers Magazine* (Spring 2018), https://magazine.rutgers.edu/features/visible-men

Credits

Mary Cassatt (1844–1926). *The Child's Bath,* **1893.** Oil on canvas, 39½ × 26 in. (100.3 cm × 66.1 cm), Art Institute of Chicago, Chicago.

Mary Cassatt (1844–1926). *The Bath,* **1890–91.** Drypoint, soft-ground etching and aquatint, printed in color from two plates, 11⅝ × 9¾ in. (29.5 × 24.8 cm), The Metropolitan Museum of Art, New York; Gift of Paul J. Sachs, 1916, Photo courtesy Universal History Archive/UIG/Bridgeman Images, New York.

Richard W. Hill. *Clan Mother,* **1971.** Watercolor, 22 × 30 in. (55.9 × 76.2 cm), Philbrook Museum of Art, Tulsa. © Richard W. Hill.

Kikugawa Eizan (1787–1867). *Mother Carrying Her Baby Son on Her Back,* **c. 1810.** Color woodcut, vertical oban diptych, 29¾ × 9¾ in. (75.8 × 24.9 cm), Fine Arts Museum of San Francisco, 1964.141.1156.

Pablo Picasso (1881–1973). *Claude Drawing, Françoise and Paloma,* **1954.** Oil on canvas, 45⅝ × 35 in. (116 × 89 cm), Musée Picasso, Paris, France. © Succession Picasso/Artists Rights Society (ARS), New York.

Barbara Hepworth (1903–1975). *Mother and Child,* **1934.** Pink ancaster stone, 10¼ × 12¼ × 8⅝ in. (26 × 31 × 22 cm), The Hepworth Wakefield, West Yorkshire. © Bowness/Hepworth Estate. Bridgeman Images, New York.

Carmen Lomas Garza (born 1948). *Cleaning Nopalitos,* **1989.** Gouache on cotton paper, 13½ × 11¾ in. (34.3 × 29.8 cm), Private collection. © Carmen Lomas Garza.

Vincent van Gogh (born 1853–1890). *First Steps (After Millet),* **1890.** Oil on canvas, 28½ × 35⅞ in. (72.4 × 91.1 cm), The Metropolitan Museum of Art, New York.

Jean-François Millet (1814–1875). *First Steps,* **c. 1858–1866.** Black chalk and pastel, 11⅝ × 18 in. (29.5 × 45.9 cm), The Cleveland Museum of Art, Cleveland.

Henry Ossawa Tanner (1859–1937). *The Banjo Lesson,* **1893.** Oil on canvas, 49 × 35½ in. (124.5 × 90.2 cm), Hampton University Museum, Hampton.

Mark Shasha (born 1961). *The Dreamers.* Oil on canvas, 24 × 36 in. (61 × 91.4 cm), © Mark Shasha.

Cbabi Bayoc. *Missed a Spot,* **2012.** Acrylic on canvas, 18 × 24 in. (45.7 × 61 cm). © Cbabi Bayoc.

Kehinde Wiley (born 1977). *The Two Sisters,* **2012.** Oil on linen, 96 × 72 in. (243.8 × 182.9 cm), Brooklyn Museum, New York. © Kehinde Wiley.

Hung Liu (born 1948). *Sister,* **2000.** Lithograph with chine collé on paper (ed. 10/75), 22 × 29¾ in. (56 × 76 cm), National Museum of Women in the Arts, Washington, D.C.; Gift of the Harry and Lea Gudelsky Foundation, Inc. © Hung Liu. Photo courtesy Nancy Hoffman Gallery.

John Singer Sargent (1856–1925). *Carnation, Lily, Lily, Rose,* **1885–86.** Oil on canvas, 68½ × 60½ in. (174 × 153.7 cm), The Tate Gallery, London. © The Tate Gallery.

Faith Ringgold (born 1930). *Tar Beach (Woman on a Beach Series #1),* **1988.** Acrylic paint on canvas bordered with printed and painted, quilted and pieced cloth, 74⅝ × 68½ in. (189.5 × 174 cm), Solomon R. Guggenheim Museum, New York. © Faith Ringgold, Artists Rights Society (ARS), New York. Art Resource, New York.

Henri Matisse (1869–1954). *The Painter's Family,* **1911.** Oil on canvas, 56¼ × 64⅜ in. (143 × 194 cm), Hermitage Museum, St. Petersburg, Russia. © Succession H. Matisse/Artists Rights Society (ARS), New York. Photo © The State Hermitage Museum/by Vladimir Terebenin.

Wayne White (born 1957). *The Louvin Brothers,* **2014.** Cardboard, acrylic paint, wood, rope, Dimensions variable. Permanent collection Country Music Hall of Fame and Museum, Nashville. Photo by Adam Reich. Courtesy of the artist and Joshua Liner Gallery.

Winslow Homer (1836–1910). *Crossing the Pasture,* **1871–72.** Oil on canvas, 38 × 26¼ in. (96.5 × 66.7 cm), Amon Carter Museum of American Art, Fort Worth.

Alice Neel (1900–1984). *The Soyer Brothers,* **1973.** Oil on canvas, 60 × 46 in. (152.4 × 116.8 cm). © The Estate of Alice Neel, Courtesy The Estate of Alice Neel and David Zwirner.

Jordan Casteel (born 1989). *Crockett Brothers,* **2015.** Oil on canvas, 54 × 72 in. (137.2 × 182.9 cm). Courtesy the artist, Sargent's Daughters, and Casey Kaplan, New York.